We all ought to be informed and aware human beings as well as creatives; creatives at least in the sense of authoring and performing our own enriched and better lives. But when we choose to enter public discourse, community engagement, and community building, we can find the mechanisms and pathways for interaction, contribution, involvement, collaboration, participation, and connection to be anemic if we do not find ourselves in a formal role in the community or media as thought leader, influencer, or expertise. Conceptualizing the public creative would allow neighbors, enthusiasts, and more informal creatives to infuse the community with their thought leadership, imagination, and experiential expertise.

Other Books by Patrick Muller

Healthcare Communication: A Rhetorical Handbook

I can cure your cancer with this poem

Forthcoming

My Oeuvre for $4 Billion

Art Genome: Mapping the 47 Dimensions and the Polyvalence of a Work-of-Art

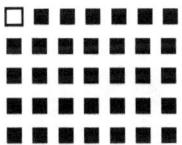

Nikos Sakethevan Publishing

Hills, Iowa ❖ Olomouc, Czechia

C✲NFLUENC&R

☉ Introduction of the Public Creative ☉

Patrick Muller

Cover photograph:
Forsythia Constellation
Patrick Muller, 2021

ISBN 978-1-257-89145-0

Patrick Muller.
Copyright 2021.
All Rights Reserved.
Just Before Dawn Edition.

CONFLUENCER

⊙�head&⊙

Symbolism

These symbols appear in the title and subtitle of Confluence. ✹ serves as an o. It represents the consideration of many perspectives, lenses, voices, frames, layers, and dimensions. &⁊ serves as an e. It represents to consider more (yes and; both/and); to engage with empathy; to follow up; to evalute; to revise; to collaborate; to converse; and to connect. ⊙ represents vision, looking in different directions -- backward, forward, inward, outward. A good confluencer welcomes and employs multiple strands of perspective, insight, expertise, and interpretation and leaves the conversation/consideration richer than upon entering.

⊙✲&⊙

Confluencer

1. an influencer who contributes from the confluence of critical and empathic thinking, informed discourse, breadth, depth, evaluation, revision, collaboration, and connection.
2. a public creative who contributes insight and perspective from experience, amateur or professional expertise, earnestness, and enthusiasm; may be an accomplished maker or artist but does not need to be.

Often, in community affairs, we routinely and repeatedly turn to a very small portfolio of informants. Usually these informants are the most distinguished experts in their field and their insight, of course, is valuable. Even within disciplines, however, there are ideological divergences. And so when we turn to one expert, not only do we ensconce ourselves in one discipline, we ensconce ourselves in a subdiscipline.

Other disciplines can contribute to the consideration. As different levels of accomplishment can

as well. A sociologist and anthropologist can offer something to the design of a highway as well as an engineer. The highly-accoladed expert, of course, informs any consideration. So can the newly-minted expert; the student; the novice; the amateur; and the enthusiast. Sometimes even a disinterested citizen may have unique input on a particular issue.

In discussions of community affairs, artists can really get the short-shrift. We turn to the scientists, experts, number crunchers, policy wonks but ignore or dismiss the storytellers, symbol conductors, metaphor wranglers, visualizers, myth spinners, and meaning makers. We can find infinite examples where a problem can be eliminated or mitigated by changing the stories or frames of reference by which it is approached. Similarly, opportunities can be uncovered or intensified by changing the stories or frames of reference by which it is approached.

And who are the experts of story, visualization, and framing? Artists.

The articulation of the public creative, or confluencer, recognizes and embraces the insightful and valuable contributions the informal, formal, amateur, or professional maker, artist, creative, or enthusiast can make to a community matter. Imagination, storytelling, visualization, framing, modeling, myth spinning, and meaning making are potent methodologies and virtually inexhaustible* resources -- and they are methodologies and resources that are in the wheelhouse of artists and creatives.

To celebrate and engage the public creative nourishes sound public practice and vibrant community building.

Anyone who wants to be can be a public creative, so we should develop and utilize mechanisms that can welcome and benefit from their insight and contributions.

* If insight, for instance, can be gained from a Shakespeare play, a used copy of the book can be had for $5; checked out free at the public library; or perhaps accessed without cost online. Anyone who wants at the moment to get their hands on that play basically can. Inexhaustible.

⊙�֎&⊙

Values

The public creative or confluencer will operate from a set of values.

Breadth / Knowledge

There are many ways of human knowing: the arts; anthropology; economics; education and learning; history; languages and linguistics; law; mathematics; medicine and healthcare; philosophy; political science; psychology; rhetoric; sociology; and ultimate concern. The confluencer is open to insights from various strands of knowledge and understanding.

Breadth / Accomplishment

Yes, the highly-accoladed expert, practicing for decades, has great wisdom to contribute to a consideration, especially one involving his or her discipline. But all contributions do not need to come from a single discipline. Nor do they need to come from the most exalted expert.

Valuable or useful contributions can come from established but non-award-winning experts; from newly-minted experts; from student experts. Contributions can come from non-experts, especially enthusiasts.

The public creative or confluencer welcomes this breadth.

Depth

There are agents and dynamics in society that invariably want us to think about issues in face value, superficial, or pretextual terms. But the public creative or confluencer tries to engage deeper thinking; considering history, context, intent, dynamics, motivations, layers, framings. When employing those elements, a more substantive, honest, and constructive consideration of the issue likely happens.

Preparation / Pre-Work

Having some knowledge of an issue and learning about its facets allow a public creative or confluencer to make a more valuable contribution to any consideration.

Co-Work

Gaining some knowledge of an issue and learning more about its facets in the moments of an issue's consideration allow a public creative or confluencer to make a more valuable contribution to any discussion of public concern or community building.

Post-Work

Continuing to gain knowledge about an issue and and learning more after the major consideration of an issue allow a public creative or confluencer to make a more valuable contribution to any consideration and to keep momentum of community building or engagement flowing.

Follow-up / Follow-up

A public creative or confluencer follows up and follows through in the consideration of an issue. A public creative keeps the word to complete some tasks upon any plan of action on or further consideration of the issue. Such follow-up sustains the momentum of community engagement or community building on this issue.

Follow-up / Evaluation

When appropriate and possible, a public creative or confluencer facilitates evaluation of a project, decision, or initiative. What good is a decision if its results don't approach the desired outcome.

Follow-up / Revision

Once there is an evaluation of a project, decision, or initiative, a public creative or confluencer facilitates, when appropriate and possible, sustainment of a decision rolling merrily along or revision of a decision that needs some improvement.

Awareness

We all live in great pockets of ignorance, no doubt, but the public creative or confluencer tries to have a basic awareness of community, current events, and the human treasure of knowledge.

Informedness

So informedness is not currently a word. It aptly describes a public creative or confluencer who tries to be somewhat informed on community, current events, human affairs, and the human treasure of knowledge.

Conversationalism

Another made-up word. A public creative or confluencer integrally engages in conversation about issues and community engagement well beyond strained greetings, pleasantries, and vapid small talk. Authentic dialogue is a true investigation tool, empathy factory, problem solver, opportunity taker, and mentor. Conversation is always part of the equation.

Collaboration

Willing to lead, partner, or go it alone, a public creative or confluencer resides in collaborative practices that can engage or build community.

Connection

Recognizing disparate strands of input and a variety of voices, the public creative or confluencer recognizes the significance and worth of assembling and nourishing connections and the adaptability, sentience, and resilience they provide.

Relationship

Values such as collaboration, conversation, follow-up, and connection do not lend themselves to one-and-done and/or superficial initiatives. Where possible and appropriate, a public creative or confluencer sustains relationships with issues (projects, decisions, initiatives), community, organizations, and other agents/participants in community building or engagement.

Multitasking

Yes, I know that research shows multitasking may not be accurate and may be deleterious. Some studies show that when the multitasking gets parsed out, tasks are actually compartmentalized into pockets of focus. From a bird's-eye view, it looks like multitasking. From a ground view, the activity is more strategic and concentrated.
Even so, the public creative or confluencer can be successful with several irons in the fire.
The confluencer may have a day job and a home life to attend to -- and yet the confluencer can also successfully volunteer to bring a neighbhorhood festival to fruition.
Despite all the challenges and demands in a public creative's life, an earnest confluencer is not to overwhelmed to extend a sincere and heartfelt greeting to another human who passes by.

Exuberance

 The public creative is open to experience and enrichment. You will not likely hear a public creative say, "I only like chamber music or symphonies composed before 1900." Or "I don't find anything of value in rockabilly or bluegrass music." Or "I like opera and theatre but I don't much care for dance." A public creative taps into the threads of creative expression and can engage many processes, creations, and voices in this wonderful dialogue.

Integration / Philosophy

 To benefit from the creative wisdom in a community, a philosophical shift needs to happen; a move from looking to one or two "certified" and usually institutional experts to a breadth of voices -- both institutional experts and creatives <u>and</u> enthusiasts and makers in the community.

Integration / Practice

New mechanisms ought to be explored to bring public creative voices and insights into the constructive and enlightening mix.

Keep active and robust lists of local creatives to solicit for insight.

For conferences and events, don't get blinded by high profile keynote speakers and "shiny object" presenters. Understand that local makers, enthusiasts, and creatives have a pulse on the energy of the community and can add nutritive contributions to the conversation, usually at a fraction of the cost of "shiny object" presenters for a cosmopolitan speakers' agency.

Curate a rotating portfolio of local creatives to provide their thought leadership in blogs, opinions, social media posts, interviews, and whatever else are the modes of conversations and considerations of the place and moment.

The intent here is not to propose an exhaustive list of mechanisms to involve and utilize public creatives but to

realize those mechanisms need to be explored, developed, sustained, and revised.

⊙✳&⊙

Introduction

This book is, by its very existence, the seminal proto-introduction to the concept of confluencer or public creative. It is the opening greeting in the conversation. It is not the comprehensive introduction or the exhaustive definition of the confluencer.

Those phenomena will fill out as confluencers practice and evolve and contribute creative insight and thought leadership to their neighborhoods, communities, and regions. A catalog that documents the many dimensions found of public creatives and the many types of contributions of public creatives can be written in the future. By someone else.

Likely by a confluencer.

Patrick Muller is the founder and director of the Wowsa Arts Champion Club that formed and underwrites the world's first cultural substrate of foundational artistic support, the Prairie Filaments Cultural Substrate as well as a public creative and the original, emergent confluencer.